# Sex-ess

# Sex-ess

SUSAN POWERS

## Praise ~

www.SusanPowers.info and her first Book, that you "NOW" have in you hands, has phenomenal potency and powerful possibility and pure potential, in each and every moment, to open you up, to who you really are already, when you let go and allow life to reveal itself to you, totally, fully and completely, in each and every single moment of "NOW" which is all that there really ever is, so will you ?

Thank you Susan, for being my inspiration, my lover, my partner, my best friend. I love the way that you trust "THE" process as you enjoy "THE" journey of life, remembering and forgetting, until "WE" don't any more. Keep on being there for me and I will live in my fullest potential enlightened self interest forever for you.

Max Man

~ Praise

www.sex-ess.com

©2014

Forward ~

If you have "THE" great good fortune, to already have

this dynamite life enhancing Bestselling Book,

by www.SusanPowers.info in your physical hands

right "NOW", you just gained instant access,

to all of "THE" worlds' best kept secrets of pre-

living your future life, SEX-ess-FULLY ©™®

Register yourself and your partner(s) "NOW" @

"THE" www.SEX-ess.com Site ©™®

for your immediate 3 VIP "ALL" Access Passes,

worth over £3,333.33p each,

to "THE" very next LIVE "THE" SEX-ess Seminar ©™® nearest to you.

by "THE" Master of "THE" Simple SEX-ess System ©™®

~ Forward

©2014

www.sex-ess.com

www.sex-ess.com

Clarification ~ ~

Owning and carrying your copy of this book with you all day,

sharing what you learn from living with "IT" each and every day,

entitles you to 3 VIP "ALL" Access Passes, worth over £3,333.33p each,

to "THE" very next LIVE "THE" SEX-ess Seminar ©™® nearest to you,

to meet with "THE" Masters of "THE" Simple SEX-ess System ©™®

seating is limited to pre-registered Members and Mentors ONLY

you must have completed reading "THE" SEX-ess Book ©™®

to attend and to learn to love & live "THE" SEX-ess ©™®

to claim your Members Access Pass simply send a

photo of your face and of your purchase receipt

to Susans' mobile phone via SMS text

UK +44-7917-890212 "NOW"

to gain your VIP privilege

preferential partner

participant pack

~ Clarification ~

©2014

www.**sex-ess.com**

## Appreciation ~

©2014

Thank you, ……………………………………………………………………

Today, ……….day, the … … …. day of the month of ……………(… …), 20 … …

for buying … … … of this book, to share with your loved ones, this week,

for committing "NOW», to learning to love yourself and all others,

optimally better and better, each day, for ever, for all,

sharing in all ways and always, living in love,

by being a shining example to all others,

who come into contact with you,

of love in intimate action,

I love you,

signed ………………………………..

**Susan Phenomenal Powers**

Susan@SusanPowers.info

www.susanpowers.info

mobile call & SMS text

UK +44-7917-890212

~ Appreciation

©2014

www.**sex-ess.com**

Dedication ~

To you, "THE" 21st Century Master of SEX-ess ©™® that you will become, by reading, this

Simple SEX-ess ©™® Book and then visiting "THE" www.SEX-ess.com Site ©™®

and then attending "THE" SEX-ess Seminar ©™® to learn and apply

immediately "THE" Super Simple SEX-ess Student System ©™®

Thank you for buying my SEX-ess Beginners Book ©™®

by "THE" Phenomenal www.susanpowers.info

together "WE" will empower "ALL"

with love always and all ways

~ Dedication

www.sex-ess.com

**Why read ? ~**

This Simple SEX-ess ©™® Beginners Book, will literally change you entire life,

not just your SEX life, but all aspects of your inner and outer experience,

of being a living and loving and deep breathing Master of "THE" Art

and "THE» Science of Simple SEX-ess-FULL Service ©™®

Register "NOW" for access @ www.SEX-ess.com ©™®

"THE" Simple SEX-ess System ©™® is the fastest, easiest and most fun way,

to take you whole life to next level and beyond your wildest imagination,

of what is "NOW" truly possible for you to allow yourself to experience,

just by reading immediately and fully this Simple SEX-ess ©™®

Beginners Book and playing with what you learn with your

Partner(s) in life, in a joyful, graceful and effortless,

way, to get "THE" most out of each and every day.

You will find that you produce radical, rapid,

real and lasting new desirable results, in

both your personal and professional life.

## Who is ? ~

"THE" Phenomenal www.susanpowers.info is, "THE" soon to be globally renowned,

award winning, best selling, Authority and Author, in "THE" brand new fields of,

Simple SEX-ess Systems ©™® and Simple SEX-ess Services ©™® and also, Simple SEX-ess Support ©™® during "THE" year, 2015. Susan lives based, in "THE" West Midlands of England in "THE" United Kingdom and travels, Globally, Speaking, Sharing, Selling, Teaching, Training, Developing and of course Writing, on "THE" Simple SEX-ess System Subject ©™® and Leading Private by invitation ONLY Residential Retreats in Exotic Environments and Luxury Location throughout "THE" world.

Susan is completing on her commitment to live by example, as "THE" Founder and Co-Creator of "THE» Global initiative,

www.SEX-ess.com

Susan is fabulously funny, incredibly intelligent, has an amazing and amusing photographic memory, that will make you laugh and remember "THE" experience of meeting her, via "THE" telephone, on "THE" Web and in "THE" World, forever.

~ Who is ?

Pretext ~

Remaining open to "THE" mystery of life, "THE" magic of "THE" moment,

"THE" sacredness of each and every breath, "THE" beauty of each person,

both inside and out, "THE" love of living fully and freely and "THE" Limitless

Possibilities of being a human being alive during these incredible times, will

bring you into direct contact, through these pages, to you authentic, innocent,

sacred simple self, embracing "THE" essence of you, "THE" deepest aspects of,

your true Full potential Higher Vibrational Self. Enjoy "THE" journey, "IT" is "ALL"

"WE" really have to share. Express and Experience fully "THE" love that you are.

~ Pretext

Context ~

Both Chance and Change favour "THE" prepared persons, be "ONE". "NOW" is "THE" only time that there really is anyway. So use "IT" as wisely as you can. By buying and sharing this Book and "THE" things you will learn from reading and applying what you come up and out with as a result, you will, in your own small way, be contributing to "THE" maturation of our entire species and you will be helping us all make life on Earth and Beyond, become more and more perfectly pleasurable, prosperous, productive and profitable. Together "WE" can "NOW" access "OUR" highest states of expanded awareness, super consciousness and unified enlightened empowered ecstatic selves. By totally letting go of control of all that is inner and outer fear and contraction, "WE" can give ourselves
"NOW" "THE" gift of becoming powerful, pivotal, perfectly positioned, people.

~ Context

## Quotes ~

Let "IT" be.

Love and let live.

Express and Experience.

Transform and Transfigure.

Share, Serve, Support and Sell.

Give up being frustrated, be fascinated.

Ask better questions, make wiser suggestions.

Assume nothing, Confirm everything, through you.

"WE" can never learn less, apply what you learn today.

Judgements steal your joy, expectations keep you unhappy.

Expect nothing, experience everything, express ecstatic elation.

How good are you really willing to allow your entire life to get "NOW" ?

When would "NOW" be "THE" very best time to allow "IT" to get that great ?

**www.sex-ess.com**

**Page 15**

**©2014**

**Gratitude ~**

**I am and "WE" are truly grateful to you for writing and sharing this Book and this "opportunity" with "US".**

~ Gratitude

©2014

www.sex-ess.com

Attitude ~

Attitude determines altitude, so you must be extremely high.

~ Attitude

Love ~

Love is all there is.

"THE" Beatles

~ Love

www.SEX-ess.com

Page 18

©2014

© Copyright ©

Copyright © 2014 by Susan Powers.

Library of Congress Control Number: 2014921401
ISBN: Hardcover 978-1-4990-9215-8
Softcover 978-1-4990-9216-5
eBook 978-1-4990-9217-2

All rights reserved. No part of this book may be reproduced or transmitted in any form or by any means, electronic or mechanical, including photocopying, recording, or by any information storage and retrieval system, without permission in writing from the copyright owner.

Any people depicted in stock imagery provided by Thinkstock are models, and such images are being used for illustrative purposes only.
Certain stock imagery © Thinkstock.

This book was printed in the United States of America.

Rev. date: 01/21/2015

To order additional copies of this book, contact:
Xlibris
800-056-3182
www.Xlibrispublishing.co.uk
Orders@Xlibrispublishing.co.uk
698527

© Copyright ©

©2014

Page 18

www.SEX-ess.com

## Contents ~

| | |
|---|---|
| Praise | 4 |
| Forward | 5 |
| Clarification ~ | 6 |
| Appreciation | 7 |
| Dedication | 8 |
| Why read ? | 9 |
| What is ?" | 10 |
| Who is ? | 11 |
| Pretext | 12 |
| Context | 13 |
| Quotes | 14 |
| Gratitude | 15 |
| Attitude | 16 |
| Love | 17 |
| Copyright | 18 |
| Contents | 19 |
| Contents | 20 |
| Contents | 21 |
| Contents | 22 |
| Preparation | 23 |
| Testimonials | 24 |
| Acknowledgements | 25 |
| Introduction | 26 |

~ Contents

## Contents ~

**"A"**
Anal .................................................................................................. 27

**"B"**
B.D.S.M—Bondage. Discipline. Sadism. Masochism ............................. 28

**"C"**
Condoms ........................................................................................... 29

**"D"**
Dildo .................................................................................................. 30

**"E"**
Erection ............................................................................................. 31

**"F"**
Fantasies ........................................................................................... 32

**"G"**
Games ............................................................................................... 33

**"H"**
Happy Anniversary ............................................................................. 34

**"I"**
Inhibitions .......................................................................................... 35

**"J"**
Jealousy ............................................................................................ 36

~ Contents

## Contents ~

**"K"**

Kissing .................................................................................. 37

**"L"**

Lingerie ................................................................................ 38

**"M"**

Masturbation ....................................................................... 39

**"N"**

Nipples ................................................................................. 40

**"O"**

Oral sex ................................................................................ 41

**"P"**

Prostate stimulation ........................................................... 42

**"Q"**

Quality time ......................................................................... 43

**"R"**

Resolution ............................................................................ 44

**"S"**

Spiritual sex ........................................................................ 45

**"T"**

Touch ................................................................................... 46

~ Contents

## Contents ~

**"U"**

Upright sex .................................................................................. 47

**"V"**

Voyeurism .................................................................................. 48

**"W"**

Woman on top .................................................................................. 49

**"X"**

Xen-erotica .................................................................................. 50

**"Y"**

Y is for yoni .................................................................................. 51

**"Z"**

Zzz .................................................................................. 52

The pleasures of sex .................................................................................. 53

Sexual encounters .................................................................................. 56

Final thoughts .................................................................................. 59

~ Contents

Coming in 2015

Testimonials ~

Coming in 2015

~ Testimonials

Acknowledgements ~

Coming in 2015

~ Acknowledgements

Introduction ~

Sex makes the world go round. I vividly remember before, when my English teacher told the class that everyone had the potential to write a book, if they discovered a subject that ignited, the passion to commit, our thoughts and ideas to paper. Sex has, for me, ignited that passion, to commit these thoughts and ideas to paper and I have now produced a book that drew, in part, from my own experiences. I am aiming to provide, you, my readers, with a deeply thought-provoking andintensely interesting journey, where love and sex are the perfect combination.

## Anal

For many heterosexual men, anal or rectal sex, has become an exciting part, of their sexual relationship. For others, this is not something that they wish to participate in today. Anal sex is very much a taboo, but, surveys now, suggest, that it is becoming much more common amongst couples. It offers the man the opportunity, to satisfy his partner, in an exciting and slightly naughty way. There are many shared nerve endings, between the vagina and the anus, which allows the male to stimulate the vagina, with a finger or vibrator, whilst engaging in anal intercourse. Anal sex is probably something you need to try first and then decide if it is for you.

**B.D.S.M.**

**Bondage. Discipline. Sadism. Masochism.**

This is a term that covers a number of sexual practices involving restraint, stimulation and role playing. It gives the male the opportunity to live out his wildest fantasies, either with his partner or within the BDSM community.

Erotic spanking using a leather whip or paddle is a major turn on. Role playing brings fresh excitement to a relationship, ranging from medical fantasies involving nurses, doctors and patients and mistresses and slaves, where the slave is the property of his mistress. Each role carries a different story to be acted out. To be restrained by being tied to the bed at the mercy of his partner, allows the submissive male to succumb to her demands and needs, at the same time and to achieve his own state of sexual ecstasy. The extreme form of BDSM, covers pleasure and pain, often using bondage, bed, table and chair, with ropes, to provide the erotic bondage.

**Condoms**

A condom is a vital contributor in protecting against Sexually Transmitted Diseases (STD), allowing couples to indulge in safe sex.

In addition, using a condom is up to 98% effective as a method of contraception. A Male and / or a Female, can enjoy sexual relationships, secure in the knowledge, that he / she is not at risk of contracting STD or causing an unwanted pregnancy.

The actual process of putting on a condom, can be a lot more fun, where a woman or a man, can use her / her lips and tongue, to help her / him, to unroll the condom, down an erect penis. Note, great care, attention to detail and sensitivity, must be taken, not to damage or rip the condom, during this.

Dildo

A dildo can be used by a male, or female, to pleasure his / her partner or, alternatively, he can watch as she pleasures herself. These can be used for vaginal and anal penetration. Dildos can also be used during foreplay by the male or female. He or she can do this by running it over his partner's skin to heighten her excitement. Closely linked to dildos, are vibrators, designed to stimulate erogenous zones for erotic satisfaction. Both males and females, can use the clitoral vibrator to provide sexual pleasure to his or her partner(s). His and / or herpartner's orgasm, can be enhanced by stimulating the clitoris. Many couples derive great pleasure by using dildos and vibrators in the bath and shower as part of their foreplay before having sex.

**Erection**

Erection can sometimes be a problem for a man if he is often nervous and over anxious when it is the first time with a new partner. The best way to deal with this situation is to stop trying and just be real with your partner. Talk to her or him and gently hold her or him. Remaining patient will allow you both or all, to relax and then, once nature takes its course, an erection will occur naturally. Again, if an erection is lost during sex, for any reason, the man should try to relax and remember that he can still satisfy his partner with his fingers and tongue. Probably the most effective aid to help maintain an erection is a ring designed to fit at the base of the penis. Blood enters the penis and is prevented from leaving it, so the erection is maintained longer.

Various creams and sprays promising to prolong erections are also available on the market.

## Fantasies

The imagination plays an important role in the enrichment of our sex lives. Sexual fantasies usually involve the man or woman having sexual activities with his or her partner(s) or with other women / men he or she knows, or with total strangers. This can be in a variety of locations and situations. Some men get great and enormous pleasure from fantasies of violence and rape, but very few would wish to translate this particular fantasy into reality. Masturbation allows your fantasies to take over and allows your imagination to take you anywhere you want and into any situation which would then provide you with a sexual release.

The most common fantasies involve the areas of dominance and submission where the man or / and woman is physically restrained and is then completely at the mercy of his or her partner(s), who then takes over, allowing him or / and her to enjoy his and / or her loss of control.

**Games**

Every relationship can go through periods of flatness when nothing seems to be happening and / or working and everything seems routine, including things in the bedroom. Many couples / groups overcome these periods, by introducing games to bring back that sparkle into their sex lives. Inviting friends, neighbours, strangers and / or others, to meet for mutual massage and / or a game of strip poker, can open up a whole new level of anticipation, excitement, range of possibilities and options. A man and / or woman's lively imagination will be able to lift his and / or her partner(s) into a world of excitement and illusion. Games can be sexual stories acted out. Games can involve sex toys. It could be a game of master-mistress scenario, where, the master, the man, takes charge of the games that can involve bondage, sex toys, storytelling and body oil. Essential in all good sex games are mutual trust between partners, the shared excitement of role-playinggames and imaginative ways to experience sex. The man must not scare his partner or hurt her beyond what is mutually acceptable. Also as a master, he and / or she must always be and remain in control of himself and / or herself.

**Happy Anniversary**

A long term relationship can be enriched by making a conscious commitment to celebrate the various high points that have happened during your times together. A considerate mate will always be ready to pamper his and / or her partner(s) on their special date(s). A sexy new dress on her birthday to wear for supper and prepared champagne will set the mood for a night of passionate lovemaking. Flowers and champagne sent on Valentine's Day will remind her how much you really love and appreciate her. Your first meeting is a special anniversary and could be a surprise weekend get-away at a hotel spa. It will ensure she and / or he gets the pampering she and / or he deserves. Celebrating anniversaries in a meaningful way doesn't happen on its own and needs proper thought and prior planning and in particular, a sensitivity to your partners preferences.

**Inhibitions**

We have previously considered that imagination plays a part in bringing excitement and passion to our sex lives. Opposite to this is a repressed attitude towards sex where a fear of letting go is a major source of sexual inhibition and often disfunction and / or malfunction.

A man and / or woman who considers keeping control as the recipe for a successful life and has sex without giving himself and / or herself to his partner can result in cold clinical sex. For him and / or her, erection and / or ejaculation are his and / or her only concern. This is a problem that creates a barrier between a man and / or woman and his and / or her partner(s). This problem will always and only get worse if not tracked. They need to spend time together, taking things slowly, exploring each other's bodies and reestablishing a deepened sacred safe space for intimacy that will overcome sexual inhibitions and repressions.

## Jealousy

No matter how strong and / or long a relationship is, there is a limit to how much a man and / or a woman can accept from his and / or her partner paying attention to another person / man / woman. The first seeds of jealousy can grow out of control and eventually destroy a relationship. To deal with the problem, a man and / or a woman has to be totally honest with himself and / or herself and his and / or her partner(s). He and / or she must tell him and / or her their true feelings and how his and / or her behavior affects him and / or her. A sensible, frank conversation will help take the relationship forward. It is equally as important for the man and / or woman to recognise his and / or her own power and self worth within the relationship, realize that he and / or she is equal in the relationship and has no need to act as his and / or her partners'keeper. Once this power is understood and appreciated, it will enable a man and a woman to give his and her partners freedom from jealousy.

**Kissing**

Kissing is both for men and women. Kissing is a great mutual pleasure shared by men and women. A passionate kiss is a clear signal that couples are attracted to each other. A kiss could always be exciting. Avoid accepting and / or giving the same kiss or boredom will set in. Take turns in who will initiate the kiss, making full use of the mouth and tongue and always remember that there is nothing quite like a really sensitive, sensual deeply connected kiss. Avoid slobbery kisses at all cost, unless your partner asks for and enjoys them.

**Lingerie**

Most men are turned on by sexy lingerie like stockings and suspenders, sexy bras and knickers. A man can derive great pleasure, from just imagining and / or actually seeing some and / or all of the underwear. He / she can surprise his / herpartner(s) by buying him / and or her sexy underwear and later on when he / she is undressing her / him and revealing the underwear, that he / she bought, it can be a massive turn on for him / her / both / all. Buying sexy underwear for a partner is both a fun and intimate experience which helps enrich the relationship.

## Masturbation

It is a widely acknowledged fact that most men masturbate even if they are married or in a relationship. It enables a man to learn how to control his orgasm which he then applies when having sex. Masturbation is good for the prostate and may help prevent prostate cancer. It can be particularly important to release sexual tension when you're not in a relationship. There is absolutely no need to feel guilty about masturbation. It provides great pleasure and enables a man to learn techniques in private. Men generally use their hands to masturbate. For women, excitement can be heightened using a vibrator or a vaginal substance of choice. Masturbation doesn't always need to be a quick fix. It can be prolonged so as to enjoy and explore your sexual responsiveness.

**Nipples**

Most mens' heads are turned by the sight of a shapely pair of breasts. A man can bring a woman to orgasm by caressing her breasts and nipples. Erect nipples are a sign that a woman is sexually excited and becoming fully aroused. A man can stimulate his partner's nipples with his penis by stroking the nipples with it and then running them around each nipple. Generally, men's nipples aren't as sensitive as that of women. Some become aroused when their nipples are fondled and some find their nipples become erect during sex.

## Oral sex

Many men are looking for intercourse and miss out on the extreme pleasures of oral sex. You can give your partner oral stimulation in many positions. Most comfortable for her is lying on her back with her legs apart. You should ask your partner what she likes but in general, start by licking the whole area of her labia, the entrance to her vagina and the clitoral hood and stem.

Gently spread her inner lips and use your tongue on the sides of the hood and the clitoris itself. The 69 position is when couples come together in positions that allow each others mouths to be near and / or on their partners' genitals and give each other oral sex at the same time. Many couples find this a good way of arousing each other, while some women and / or men prefer to receive cunnilingus, separately, enabling them to concentrate on themselves and their own sexual pleasure. Once again, the message is to ask your partner(s) what she and / or he likes and what gives them the most satisfaction, fulfilment and / or pleasure.

**Prostate stimulation**

The prostate is often forgotten as a man's sex organ. It is located at the top of the anal passage and by stimulation through a massage, the man may be, can be and / or will be brought to orgasm. This involves pressing it in a sustained regular rhythm to give maximum pleasure during masturbation. Keep your fingers on the prostate until ejaculation to heighten the pleasure. There are a variety of excellent ways to cause anal vibrations and lubrications designed foroptimally pleasurable prostate stimulation.

**Quality time**

Lack of investing quality time with each other, is a major reason for the breakdown of many relationships. Couples and all relationships, that drift apart and stop communicating with each other, run the risk of losing the connection. Simply always remember to invest the quality and alone time, that is a necessity, to maintain a high frequency of interaction and sustaining a bright shared vision of the future of the relationship, to keep the context alive and well.

The misery and unhappiness of breaking up could be avoided by couples if they make quality time for each other, allowing the relationship to grow and flourish with the pace and demands of a modern life and this is not always easy. Set aside time to talk about each other›s day and what is going on in your daily lives. Make sure that you don›t neglect your social life make by making an effort to surprise her and / or him with a night out at the cinema or dinner at a restaurant. Most importantly, don›t allow your sex life to suffer because you are too tired or busy to spend time in the bedroom. Make your relationship your number one priority and always find the quality time it deserves.

~ "Q"

**Resolution**

Men are seen as insensitive to their partner's feelings when they close down after sex. The reason for this is physiological and not out of neglect for their partner's feelings. The penis becomes limp and he returns to his former relaxed un-stimulated state. The woman is left full of happiness after orgasm and can often remain aroused for some time. It is important for a man to recognize these different states and to be sensitive to his partner's needs. A woman feels let down by a man who switches off after orgasm and leaves her alone afterwards.

**Spiritual sex**

During sex, chemicals are generated by the body and brain which can lead to spiritual experiences within the mind. It is an experience where a state of tranquility takes over the body and you and your partner become almost as one with the physical and mental boundaries between you slowly dissolving and disappearing.

To achieve this state during sex, try to coordinate your breathing rhythm, to become simultaneous with your partner(s)'. Persevere, sustain and maintain this unified rhythm of combined breathing and generally, you will access, achieve, deepen and prolong, a heightened state of unification, oneness and bliss, dissolving into one body and one mind.

Sharing a shower and / or bath and / or massage before and / or after sex, can deepen and prolong the connection between partners.

## Touch

The sexual power of touch is often massively underestimated. A strong relationship thrives on couples and partners touching whenever they can and simply cuddling as often as possible. It is a natural thing to do and a truly magical way to communicate their love for each other. Massage is an ideal way of exploring your partner's body and at the same time helping him and / or her to relax. Intimate touch and sensual massage can also be the start of a sexual activity. You and your partner could strip naked and explore each other's body. Make as much time as possible to touch and cuddle each other. Your relationship will thrive on this intimate physical contact.

**Upright sex**

Upright positions are when you are overtaken by a sudden surge of passion and you have an immediate need for urgent spontaneous sex. You do it then and there without the need to undress or find the bedroom. Sex takes place while you and your partner(s) are both standing upright and are seized with desire and passion for each other. The excitement is enhanced by the risk of acting spontaneously, no matter what location you find yourselves in. It can be outdoors, your home, or even on the office table or chair. It will enable couples to vary their standing positions as the man enters his partner. She and / or he can lift one leg to open the vagina and / or anus a little more. The stronger and more acrobatic that a man and / or woman is, the more options she and / or he have, to hold your partner(s) with both legs off the ground. This would be a time to let imagination and passion run wild.

For the more adventurous among you, there is the ancient Art and Science of Urine Therapy. To the Western mind, this may occur as unhygienic and / or unhealthy. If you take the time to research this subject, you will discover a whole new World of optimal wellness opportunities and when shared with your partner(s), a deep spiritual, biological, chemical, electromagnetic and even unified gravitational field of oneness can be established, sustained, maintained and then advanced. This can lead to metaphysical experiences of telepathy and knowing, clear all diseases (lack of eases) known to humankind and eventually even set up the required basic conditions for accessing super consciousness and permanent perfect health and total enlightenment.

**Voyeurism**

Watching, one or more other people, engaged in masturbation, self pleasuring and / or sexual activity, live and / or prerecorded and replayed, for almost all individuals and many couples, enhances, enriches and sources, a new dimension and paradigm, in their sexual activity. Most often caused, by an subconscious and / or unconscious, instinct to procreate, where pheromones (natural aromas) produce strong sexual arousal. The excitement can be heightened when the man and / or woman, is masturbating during this activity. Voyeurism, has also become a popular activity with those who visit pre-arranged locations to watch couples having sex. The opportunity is also there for them to join in, if they wish to do so. Voyeurism, although disapproved of by some, is really another form of sexual stimulation where a man and / or a womancan relive the event, either with and / or without, his and / or her, partner or by himself and / or herself.

**Woman on top**

One of the greatest turn-on for most men is when the woman takes control and assumes the woman-on-top position. Her active participation in the sex and the pleasure she enjoys heightens the man's excitement. From the sitting upright position, he can stimulate her breasts as she sets the tempo and depth of penetration. This is a position that is probably second in popularity to the missionary position.

The introduction of oil can enhance the experience as you caress, stroke, and massage your lover's body. Remember the best sex is timeless and should be enjoyed at a leisurely pace.

## Xen-erotica

Xen-erotica is a contemporary term for sexual attraction to strangers. Men have always been seen as the predators in the sexual jungle and therefore, sexual attraction to strangers leading to one night stands has always been a regular part of their sexual encounters. Now, in 2014, things have moved on and women are just as likely to end up in bed with a stranger they have just met. Alcohol is a major factor in these liaisons for there are now many more women and men who like no strings attached. Casual sexual encounters are exactly what they want and are looking for, with the excitement of a new conquest without any level of commitment. However, this lifestyle can eventually take its toll leading to feelings of isolation and emptiness. Some films, captured this perfectly, where the leading man is incapable of conducting a normal relationship with a female colleague. The message being that a stable loving stable sacred intimate relationship offers so much more then opportunistic encounters with strangers.

Y is for yoni

Yoni is an ancient term for the vagina or a representation of a vagina, appearing in the well know book of "an enormous variety of positions", known as the Kama Sutra. The "Y" curve Kama Sutra sex position is one of the most exciting and satisfying sex positions for the man. The "Y" curve is where the woman lies facedown with her legs on the bed and her torso and head hanging over the side with her palms on the floor supporting her weight. The man positions himself over her and enters from behind, his legs straight and inside hers.

By holding on to her hips for leverage, he is able to keep his head and shoulders raised high from this position. He is able achieve a strong thrust and deep penetration. It is a truly erotic and satisfying experience for both the man and woman.

**Zzz**

Sleep or lack of it can have serious implications on a man's sexual health. Evidence suggests that when a man is sleeping less than five hours a night, his testosterone level is lowered by up to 15%. Furthermore, a recent survey has found a strong link between lack of sleep and sexual dysfunction including libido impotence and erectile dysfunction. Sleep is vital to the body being able to function. A single restless night can raise stress levels and lower a man's arousal. A better rested man is a man better in sex. Most will agree that a minimum of 8 hours sleep is needed by most men to function at their best.

## The pleasures of sex

### Water sex

Making love in the bath is an ideal opportunity to enjoy pleasurable and fun sex. You can feel clean and comfortable. Bathing enhances relaxing actions and intimacy. Remember your body becomes weightless in water, enabling you to float into sexual positions. One of the most wonderful sexual experiences, is making love in the warm sea after dark, when no one else is around, closely followed by sexual frolics in the shower.

You and your lover can indulge in a sensual, soaking, soapy massage exploring every inch of each other's bodies, as a prelude to exciting and passionate lovemaking. Water will always be a sensual option and is usually easily available in most locations, for you and your partner(s) to indulge your sexual fantasies.

### X-rated games

This is an opportunity for your imagination to run wild as you think of games that you and your lover can play.

To spice up your sex life, a particular favorite game of mine is spinning the bottle, where you remove a piece of clothing when the bottle points to you. Another favorite is blindfolding your lover then leading him and / or her into the bedroom and tying his and / or her hands to the bed before performing oral sex on him and / or her.

He and / or she in turn can respond by performing cunnilingus on you. His and / or her tongue can flick and twirl around your clitoris and / or anus (stay and keep safe and clean) and occasionally even entering into your vagina and / or anus.

The number and variety of possible sex games are endless and it is for you to choose those that will stimulate and enrich your love life, the best and the most.

The zone

When athletes are performing at their highest level, they often refer to this as being in the zone. It is true that with sex you can also be in the zone, a state in which a woman is only aware of what her partner is doing and what she is doing andexperiencing a feeling of pure perfect blissful ecstasy as they make love. Although most are unable

"Pleasure" ~

to deliberately enter the zone, unless well trained in Tantra from the East, you can do a number of things to help it along.

Get a place for you and your partner with no outside distractions. Heighten the mood by watching a sexy film and follow this through by making love to music playing with aroma therapy candles burning and / or diffusers in the background. Think of different things that might help you to enter the zone and gradually incorporate these as a way in which to enter the end and highest realms of sexual pleasure and deepest intimacy.

**Sexual encounters**

Sally and Jim were strangers when they first met. They have been married for four years and to celebrate the anniversary of their first meeting they came up with a very special routine. Once a year, on the 14th of April, they re-enact in exact detail that very first meeting.

It began when they shared a hotel lift to attend a training seminar for a national glass manufacturing company they both worked for. Sally in Reading and Jim in Bristol, England. The moment their eyes met in the lift they both felt a tremendous rush of sexual energy.

They exchanged a passionate kiss which only ended when the lift reached the hotel restaurant. After sharing an intimate dinner wherein they seemed to talk nonstop and got to know each other, they left the restaurant and went back to Jim's room which was coincidently on the same floor as Sally's. They made love all night and by morning they were both exhausted but duty called and so they spent the day considering the merits and sales techniques relating to heavy duty industrial glass.

"Encounters" ~

The seminar seemed to go on forever and all they wanted to do was to go back to Jim's room for another night of passion.

Many more nights followed and after 3 months, Sally landed a transfer to Bristol and moved into Jim's flat.

They were married after 6 months and moved into a brand new house.

As their relationship and careers got stronger they never forgot about that first meeting and they found their own unique way of celebrating that special occasion. Of course, the glass seminar is not included in the celebration but everything else definitely is a re-enactment of their original first night out.

My husband was working away over the weekend so I arranged to have an evening out with my single girlfriend Carol, a chance to catch up and have some drinks and enjoy a fun evening. We went to a local night club and soon found we were dancing and enjoying the company of two young guys who bought us drinks and at closing time, Carol invited them back to her place for coffee.

We sat chatting and drinking coffee. And after a while, Carol and her guy slipped away and before long there were noises coming out of the bedroom. There was no doubt about what was going on in there.

Then without warning, the guy I was with moved closer and began kissing me passionately and soon we began tearing at each other's clothes. And then we were both completely naked.

He pushed me down on my back and began to have sex with me.

It felt good and we both climaxed and then we eventually fell asleep.

I woke up the next morning racked with guilt. He was still asleep and I felt awful as this was the first time I had cheated on my husband. All I could do was get dressed and get out of there as quickly as possible. I never saw the guy again and I will never cheat on my husband again.

**THE END OF SEXUAL ENCOUNTERS**

"Final Thoughts" ~

**Final thoughts**

I hope you enjoyed reading my book and found it funny, inspirational, and helpful. Here are a few quotes on the subject of sex which are both amusing and thought-provoking on the subject.

1. "I don't know the question but sex is definitely the answer."

    -Woody Allen-

2. "I remember when the air was clean and sex was dirty."

    -George Allen-

3. "I'll come and make love to you at 5 o'clock if I'm late, start without me."

    -Talulah Bank Head-

4. "Sex is always about emotions, good sex is about free emotions, bad sex is about blocked emotions."

    -Deepak Chopra-

5. "Sex is an emotion in motion."

    -Mae West-

6. "If reincarnation exists, I want to come back as Warren Beatty's finger tips."

    -Woody Allen-

The end of final thoughts

~ "Final Thoughts"

www.ingramcontent.com/pod-product-compliance
Lightning Source LLC
Chambersburg PA
CBHW021040180526
45163CB00005B/2210